D1003266

SILVER
JEWELLERY
OF OMAN

BY

JEHAN S. RAJAB

Tareq Rajab Museum
Kuwait

DEDICATION

This small book is dedicated to His Majesty Sultan Qaboos Bin Said al Said and the people of the Sultanate of Oman

Published in 1997 by the Tareq Rajab Museum, Kuwait

© copyright 1997 Jehan S Rajab

ISBN 1 86064 310 8

All objects illustrated are from the

TAREQ RAJAB MUSEUM

P.O.Box: 6156. 32036 Hawalli, Kuwait - Tel: 5318060, 5318061 - Fax: (965) 5319924

"Silver Jewellery of Oman" adapted from an article written for Arts of Asia - Hong Kong

Designed & Produced by Design House P.O.Box: 55064 Dubai, U.A.E.

ACKNOWLEDGEMENTS

There are many people in Oman to whom we have spoken over the years about their heritage, their arts and crafts, but those named below have been most helpful.

Mr. Ahmad el Suleimani of Nizwa.
Mr. Tariq Ahmad Al Sutohy, the General Manager of the Sur Beach Hotel in Sur.
Mr. Salim of the Sur Beach Hotel.
Mr. Zael bin Khalid bin Salim Daoudi of Sur.
Mr. Mohammad Safdar of the New English School, Kuwait for typing the manuscript.
Mr. Mohammed Arshad Asif for all his help with the production and printing of this book.

In particular, I would like to thank **HE Ambassador Abdullah** and **Mrs. Safia al Kharusi**, as they were the people who first introduced us to their lovely country

"My husband, **Tareq S Rajab** provided me with so much help that this is as much his book as mine."

Jehan S Rajab
Tareq Rajab Museum
Kuwait.

Photography:
Tareq S Rajab, Jehan S Rajab.
The three women from the Wahiba Sands courtesy of Alan Keohane of London

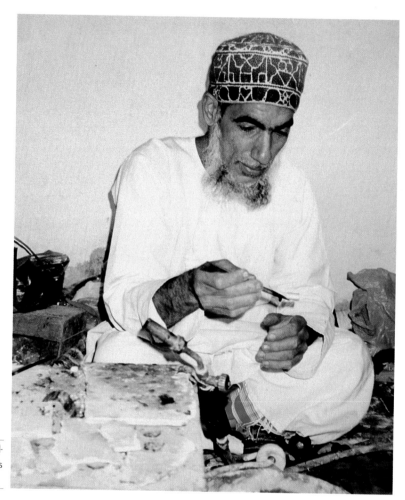

1. Ahmad al Ṣuleimani, the Nizwa silversmith who has been working at his profession for over 30 years.

THE SILVER OF THE SULTANATE OF OMAN

THE LANDSCAPE OF OMAN, an Arab Muslim country Iying in the southeastern part of the Arabian peninsula, is a dramatic one. Dark cliffs which drop down to an azure sea. The villages are watered by a sophisticated and ancient Falaj system that Omani tradition attributes to King Suleiman bin Daoud (the biblical Solomon) who is reputed to have ordered his djinns to create some ten thousand constantly full irrigation water channels. The word Falaj is of considerable antiquity and comes from a Semitic root. It is used to mean the irrigation system that leads from the water table or wells in channels, not only on flat ground but around mountain slopes, so making use of the silt that can be found there. Oman's long coastline stretches up part of the Arabian

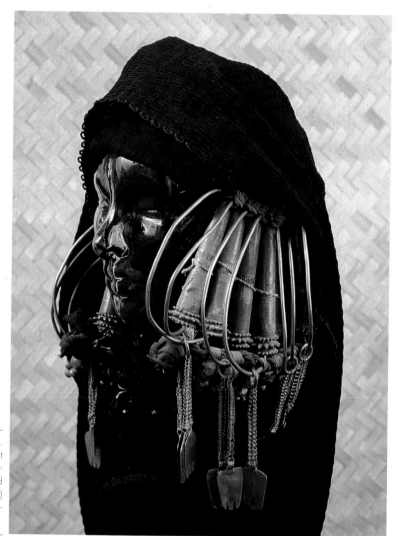

2. Headdress worn by Bedu women . This style was worn not only in Oman but in the UAE as well. These clusters of earrings seem to have been popular and Princess Salme (c. 1868 photo No 32) appears to be wearing similar type earrings under her headdress.

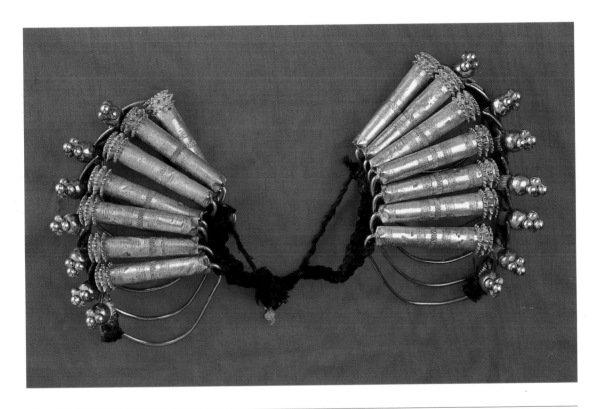

3. A spectacular headdress worn either side of the head probably in the same manner as (No 2).

Gulf, through the Gulf of Oman and out into the Arabian sea. Strung out along the Batinah coastline are small fishing villages behind groves of waving date palms that provided so many with a nutritious source of food. Sohar, the famous tenth century port with its trading links to China, is still there and thriving once more though in a different manner.

In the interior of the country lies the still walled town of Bahla, well-known for its pottery, and Nakhl, once a centre of indigo dyeing and now a

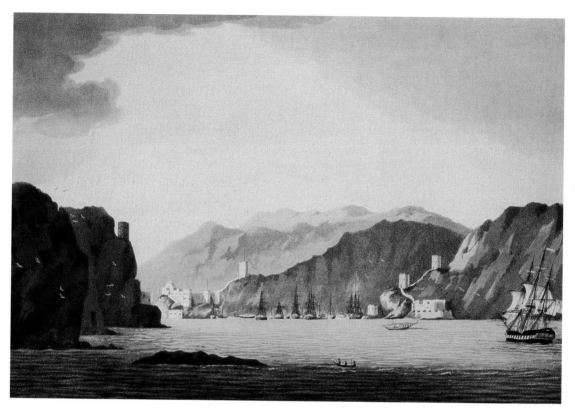

4. 'Muskat Harbour from the Fisher-men's Rock'. Published April 1813 by W. Haines.

favourite picnic area because of the hot springs that gush out of the mountainside with the town and its fort below. Further inland is Nizwa, a town particularly famous for silver work in jewellery and Khanjar, the curved knives with intricate silver weaving on their scabbards.

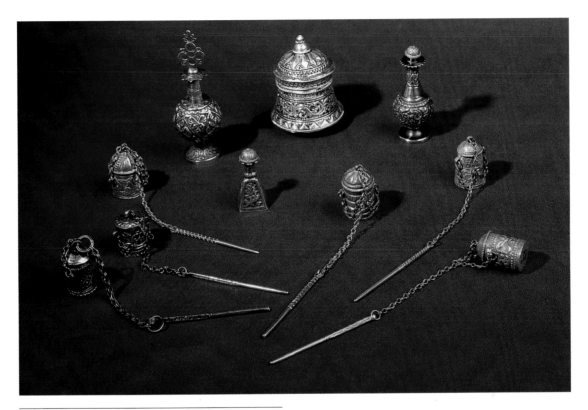

5. Silver 'Kohl' containers for women .

The towns of Rostaq, Ibri, Sur, the capital Muscat and Mutrah, all once had a distinctive style to their prolific silver work. Previously the Batinah coast, the interior, the Sharkiya and Dhofar, had regional differences in their designs. Some elements such as the Manjad were only worn in Dhofar. Manjad were two long decorative chains worn crosswise over both shoulders and hanging down to the hips. A similar design could be found in the Greek and then the Byzantine period, and until comparatively recently was worn by some tribal women in Jordan. Due to the system of efficient roads and

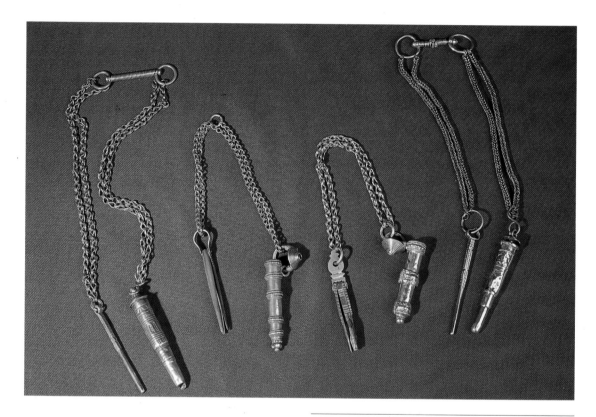

greater ease of movement, styles have become more general. The capital being a port in contact with India and East Africa, and Omanis travelling as far afield as China and Indonesia, means Omani jewellery and crafts often show evidence of artistic influences given and received as a result of the extensive travels undertaken by sailors and traders.

6. Silver 'Kohl' containers for men . Both women and men wore 'kohl' not only for beautification purposes, but because they believed it was medicinal and helped deflect the fierce sunshine. The second and third from the left carry tweezers for the removal of thorns. Men carried the containers in their belt or sometimes in their head wraps.

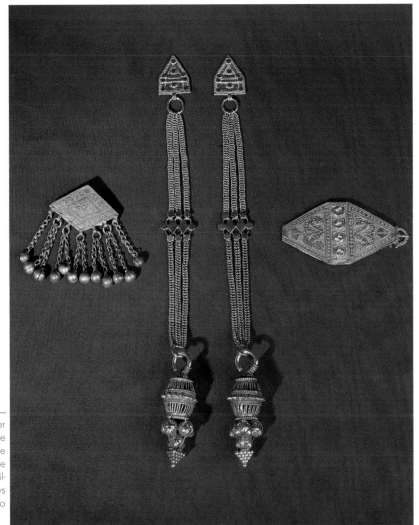

7. L to R. A brooch and two silver earpieces worn either side of the head which would be held in place by silver chain or strings across the head and under headwraps. A silver belt buckle worn by young boys before they were old enough to wear the 'Khanjar' or dagger.

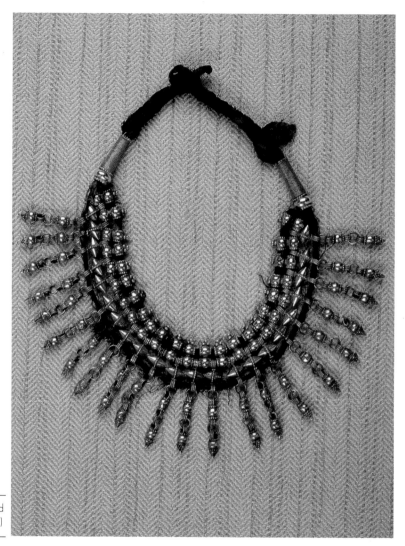

8. A striking necklace of silver threaded
with a sturdy piece of rope. (see No.9)

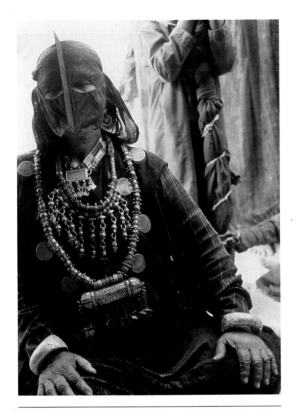

9. A lady from the Wahiba Sands wearing her jewellery .(photograph, Courtesy of Alan Keohane, London)

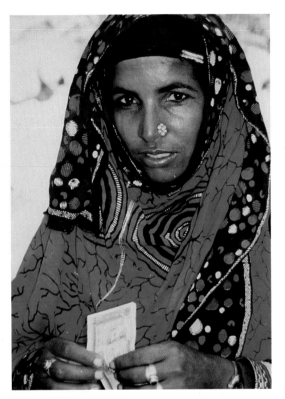

10. A young woman from Wadi Bani Khalid.

To the southeast of the country lies the Wahiba Sands, a unique desert roughly one hundred miles long by about fifty miles wide. Its dunes, reaching a height of two hundred feet, are rosy red at the bottom gradually becoming honey coloured towards the top. From the road now skirting the Sands an impression is given of an upturned pinkish bowl of sand that could be pushed back. Studies by the Royal Geographical Society expedition of 1986 have shown that due to strong winds blowing between March to July, the dunes move inland at an annual rate of about ten metres.

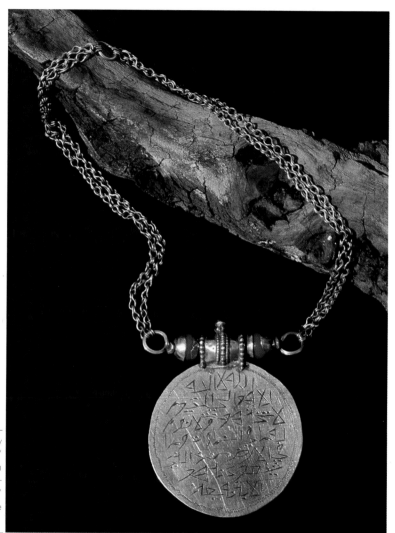

11. The front of a silver disc usually inscribed with the verse 'Ayat al Kursi' from the Holy Qur'an . Very often engraved on the reverse is a small anthropomorphic figure reputed to be a 'djinn' captured and kept there to avert evil. See picture 13.

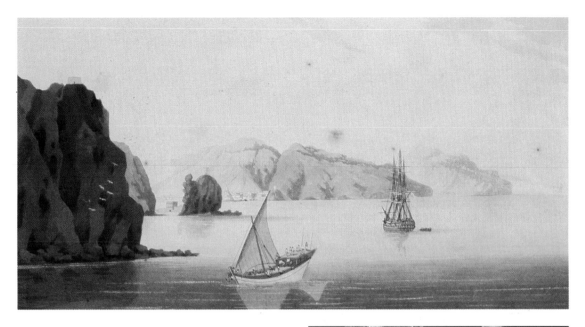

12. 'A view of Mutra from the East', published April 1813 by W. Haines.

►

13. The back of the silver disc (No.11). Very often engraved on the reverse is a small anthropomorphic figure reputed to be a 'djinn' captured and kept there to avert evil.

It is a living desert with its animals and vegetation adapted to its particular conditions and inhabited by a number of tribes who have chosen to remain there. The women of these tribes wear some of the

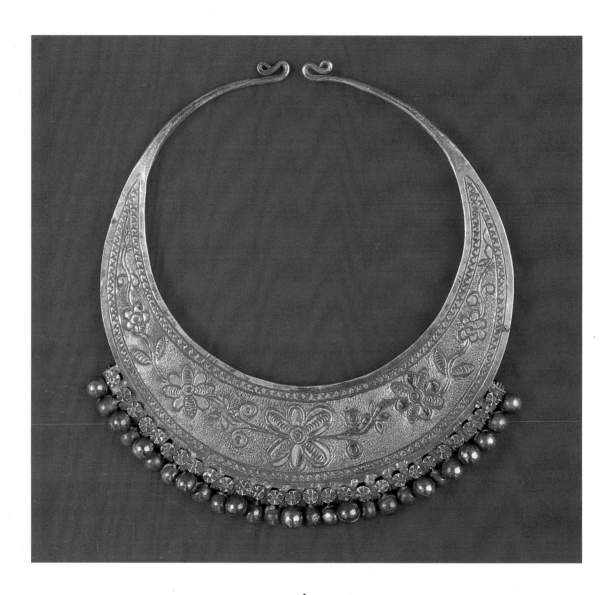

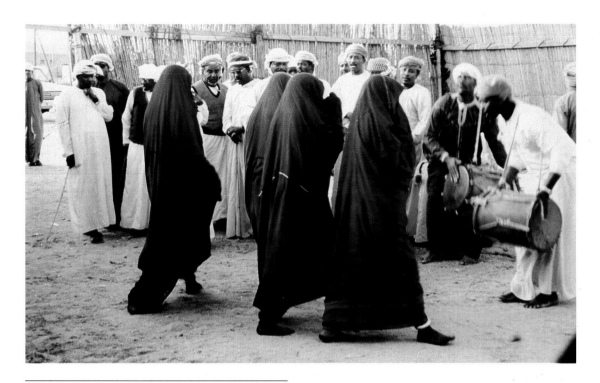

14. The Drummers at a 'Maidan' or meeting in Sur. The woman on the right is wearing a pair of silver Sur anklets. The women are draped in the beautiful and locally woven silk mantles.

◀

15. A neckpiece, possibly from Sur. These neckpieces bear a striking likeness in shape and sometimes even design to those worn by the Chinese Hill tribes of Thailand and Hainan. It is interesting that the Arabs traded in Hainan from a very early period . The Hill tribes of Thailand, who wear prolific silver jewellery originated from Hainan.

most outstanding jewellery, which these days would probably be called "conceptual": neck pieces of heavy nielloed round plaques, a triangular shaped necklace of bunches of silver beads with the stiff-base strung with heavy bits of coral, as well as a number of different shaped earrings. Most interesting of all, the women individually make and cover their hair with finely plaited leather helmets of goat skin which they decorate with a pattern of small

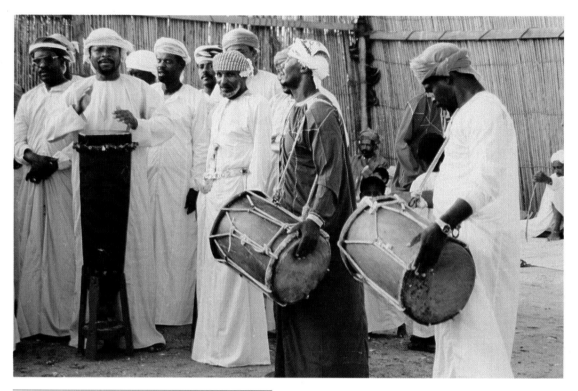

16. The Drummers at a 'Maidan' or meeting in Sur.

coin-shaped silver pieces. One woman was asked if each person made their own; would she for example ever wear her mother's hat? Rather scornfully she replied, "Of course not, my head is a different shape than hers". How and when did the idea for this singular and interesting head piece appear? It is hard to resist speculating on possible origins, remembering that in the sixteenth century the Portuguese, followed by Dutch and British man-of-war ships appeared up and down the Gulf and the Arabian sea. Perhaps too the shape derived from African hairstyles.

▶

17. Near the village of Tewi on the coastal road to Sur.

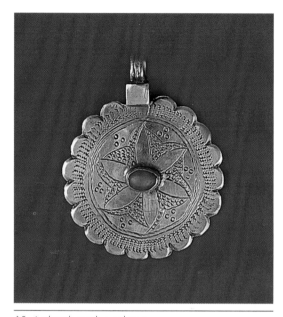

18. A silver disc with a red stone.

tribes in the United Arab Emirates. Other things noticeable about much Omani jewellery are the features of great antiquity that appear to relate to ancient Persia, Ur in Mesopotamia, the Phoenicians and of course India. What gives it such individuality is the way the Omanis have interpreted it in their own manner.

To the south of the country is Dhofar, which is not only the mountainous home of the frankincense

19. "Selma", a young girl's necklace with a Maria Theresa dollar as its main decoration.

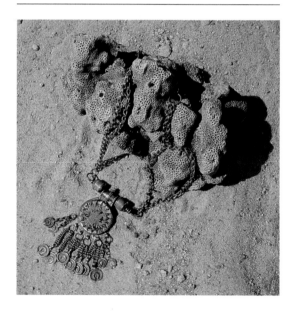

Another interesting, rather attractive and certainly unusual design, featured a cluster of slim cone-shaped silver "earrings" with wrapped and wire-spike decorations, worn in bunches of six either side of the face and attached across the head by plaited rope or chain. The cones lay across the cheeks somewhat in the fashion of a spread of cards, with the connecting rope or chain hidden under the head wraps (No.2). It seems to be a type of decoration that might be favoured by the women of the Sands but was also worn by possibly related

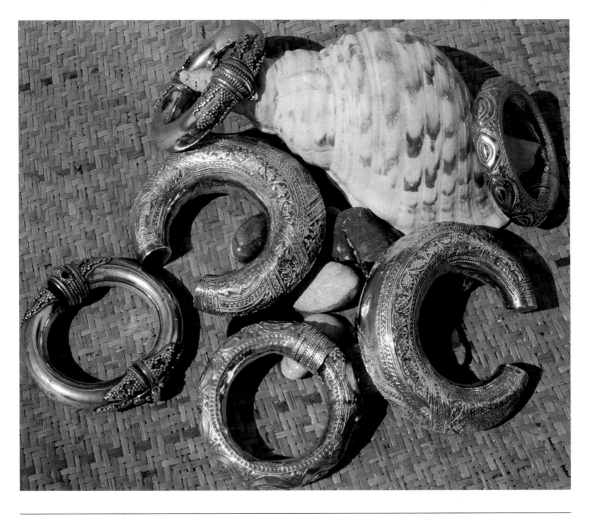

20. Anklets from Oman . The anklet with the 'eye' motif leaning to the right of the shell probably came from Zanzibar.

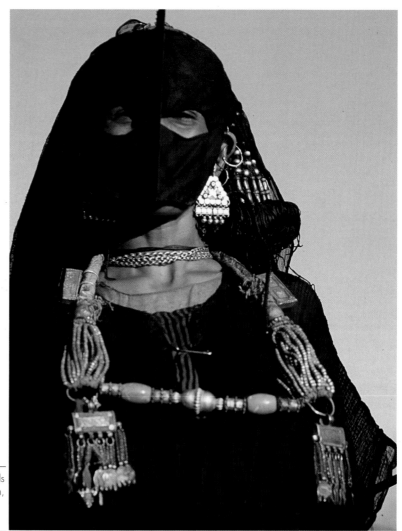

21. A lady from the Wahiba Sands wearing her jewellery. .(photograph, Courtesy of Alan Keohane, London)

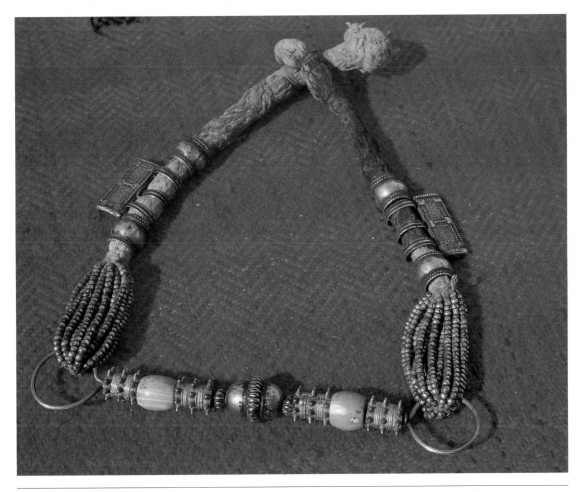

22. 'Hunkun' This necklace of spectacular and original design is worn by women in the Wahiba Sands (see photo 21).
Such necklaces were made in Nizwa and possibly in other towns such as Al Hamra, or Sanaw which is the market town that caters to the Bedouin from the Sands.

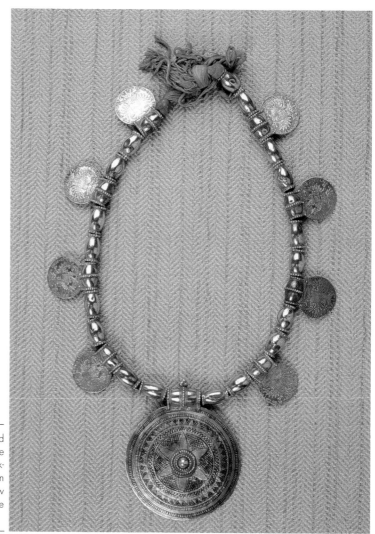

23. 'Sumpt' This necklace of spectacular and original design is worn by women in the Wahiba Sands (see photo 24). Such necklaces were made in Nizwa and possibly in other towns such as Al Hamra, or Sanaw which is the market town that caters to the Bedouin from the Sands.

period, eager to have a break from the fierce heat prevailing in the rest of the country.

Mists swirl eerily up in the mountains and along the excellent modern Mughaysil road that climbs up for eight kilometres reaching 220 metres above sea level. Many camels can be seen plodding haughtily along the road and indeed everywhere, even down on the flat plain and along the white beaches with their fringe of waving coconut trees. At this season a visitor could be offered a bowl of warm, refreshing camel milk, which to the unwary can have a slightly purgative effect.

An interesting leather and silver wedge shaped head cap was once worn in Salalah but is now all but impossible to find. Instead the women prefer to don the new gold versions at weddings and other festivals. They also wear a richly embroidered dress with the hem dipping behind and the front slightly raised to show off tight, elegant (Sirwal) or the embroidered cuffs of their trousers.

Between the capital Muscat and the Dhofari capital Salalah runs an impressive road cutting through the Jiddat Al Harasis desert. So desolate was this area before the road was built, it was 1955 before the first truck crossed it. In this place live the tribal Harasis who had protected the last known herd of Arabian oryx. In 1972 hunters from outside the Sultanate shot the remaining few animals, and

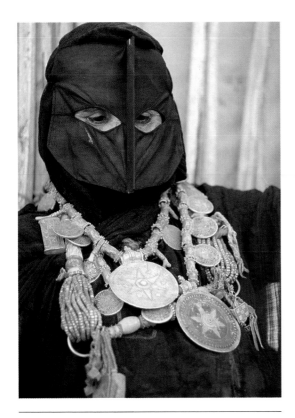

24. A lady from the Wahiba Sands wearing her jewellery .

tree but also catches the southeasterly monsoon rainfall from June to September. When the rains are good the entire countryside turns a lush tender green with cool breezes and swirling mists. These days many visitors come during the monsoon

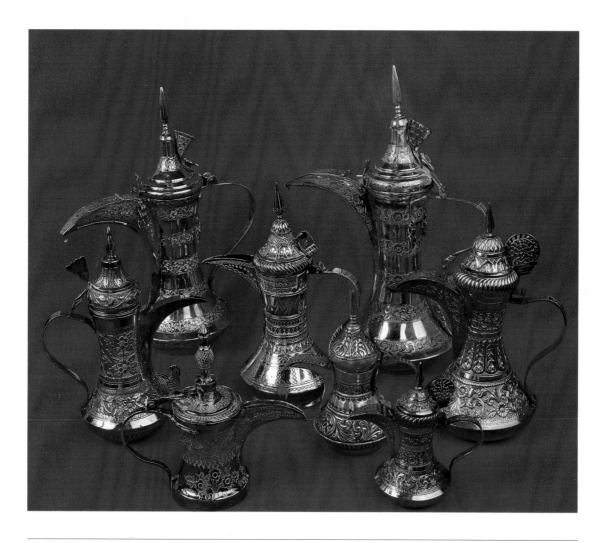

25. Silver coffee pots from Nizwa; the small squat one may have come from Muscat.

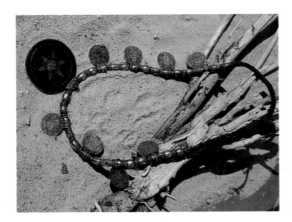

26. 'Sumpt' or 'altah', a necklace with silver spacer beads strung onto a rope with eight Maria Theresa dollars and a neilloed disc in the centre. It is quite similar to the one worn by the Wahiba Sands woman (No 24). This type was popular and worn throughout a wide area. Palm juice was sometimes used instead of niello work to get the black colour on the discs.

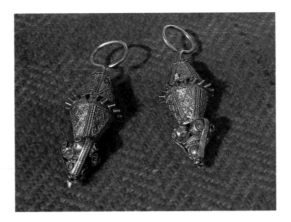

27. Earrings with the 'mulberry' finials, a type similar to those found in ancient Cyprus and numerous other old civilizations such as Ptolemaic Egypt (c.300 - 100BC) . These earrings are hung from silver chains or strings across the head (as No .2) under the headwraps .

except for some in zoos they became virtually extinct. With the help of H.M. Sultan Qaboos a small herd was returned from California to be gradually re-established in the desert. After their release the Harasis once again became their protectors, and now Rangers from the tribe equipped with radios and guns patrol the area. Once more the oryx, with the tall straight horns seen on ancient stele and artefacts, are slowly increasing in the wild.

Another dramatic coastline along to the south leads to a town called Sur. Still well-known for its boat building and fishing, there was once a sizeable silk weaving industry here. Its women wore a particular style of silver jewellery as well as a black net Thob (an overdress) with huge sleeves for draping over the head with distinctive silver thread patterns down the chest and on the back. If one drives along the coast to Sur, a cluster of shy little gazelles with large startled eyes can sometimes be seen peeping over the scrub before turning rapidly and bounding away with a wave of their stumpy tails. The cunning fox might also be

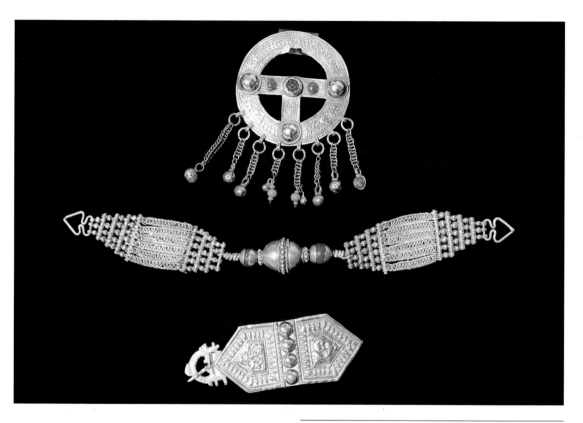

28. Top: A hair decoration from the Interior maybe Bahla or Jabrin. Centre: a necklace probably from Sur . Bottom: A young boy's belt buckle, probably crafted in Nizwa, which was worn until he was old enough to wear the 'Khanjar'

spotted back at the foot of mountains from which freshwater pools bubble up. Some of these small places look quite incredibly lovely with palm trees and reeds of deep green edging the mountainous caverns and gorges. In contrast, harsh barren mountain tops with their constantly shifting

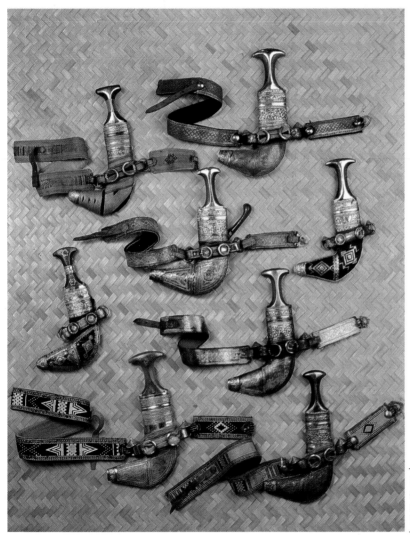

29. "Khanjar' or Omani daggers with a flat T-shaped top. Master silver-smiths made 'Khanjar' in Nizwa, Ibri, Rostaq, Muscat etc.

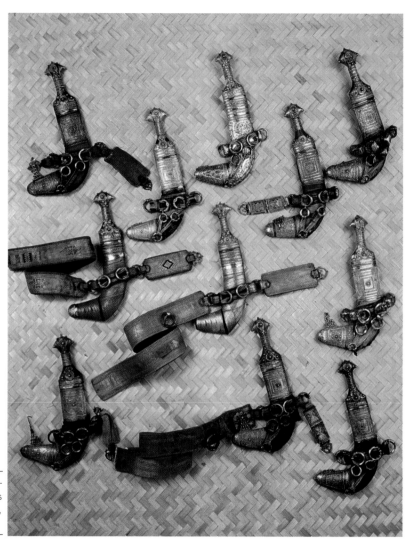

30. 'Saidi Khanjar' or Omani daggers (No.51). Master silversmiths made 'Khanjar' in Nizwa, Ibri, Rostaq, Muscat etc

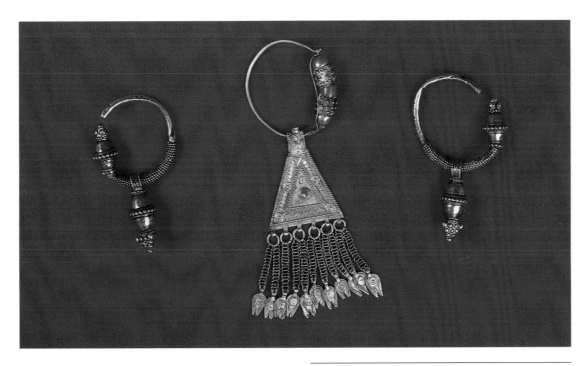

shadows provide a scene of never ending drama and interest.

This short introduction to the background of jewellery in Oman will give the reader, I hope, some idea of this very ancient land which has not only rich silver and goldsmithing traditions, but architectural, weaving and needlework ones as well. Part of Oman's cultural heritage includes wood carving

31. Three earrings, the middle one with pendants of stylized 'Khamsa' or 'Hands of Fatma"hanging from it.. The mulberry - shaped design at the bottom of the earrings is a very old one and could be seen in India, Iran, Iraq and as far afield as ancient Palestine. Sometimes earrings were worn along and up the ears (see No. 21). Princess Salme (No. 32) appears to be wearing a cluster of the mulberry type earrings.

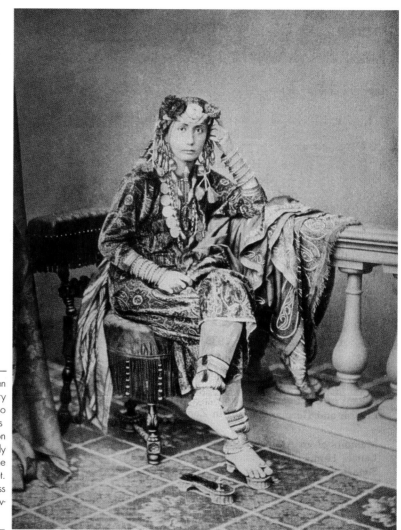

32. Princess Salme bint Sa'id ibn Sultan of Zanzibar in 1868 wearing a very similar necklace to No. 33. She is also wearing multiple "mulberry" earrings (No. 27) and two pairs of anklets on each foot. The bottom pair are probably from Muscat (No. 56) the top one appears to be the large Nizwa anklet. It is probable that as she was a Princess of Oman and Zanzibar that her jewellery was gold rather than silver.

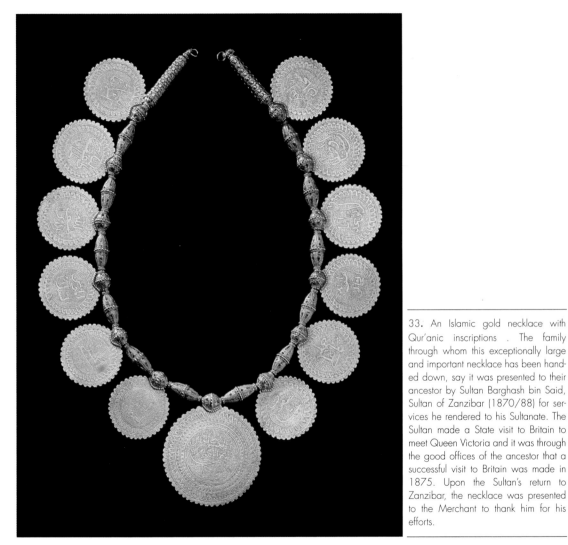

33. An Islamic gold necklace with Qur'anic inscriptions . The family through whom this exceptionally large and important necklace has been handed down, say it was presented to their ancestor by Sultan Barghash bin Said, Sultan of Zanzibar (1870/88) for services he rendered to his Sultanate. The Sultan made a State visit to Britain to meet Queen Victoria and it was through the good offices of the ancestor that a successful visit to Britain was made in 1875. Upon the Sultan's return to Zanzibar, the necklace was presented to the Merchant to thank him for his efforts.

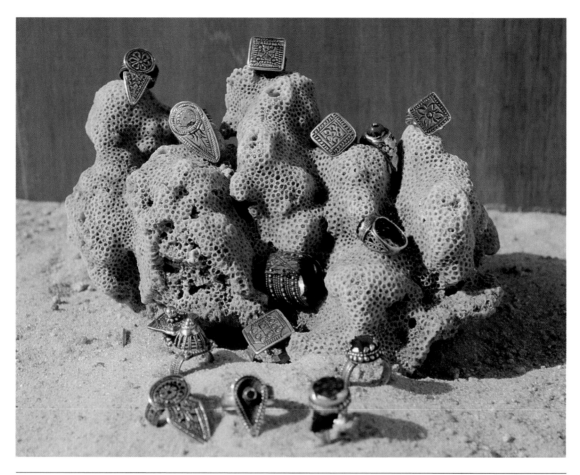

34. A selection of silver rings. Rings set with red stones were generally worn by men. The ring on the right, angled on the middle of the coral with some decorative work on the shank, is inset with a piece of very dark glass. When held up to the light the glass takes on a beautiful red-mauve colour. The two on the sand to the right are probably men's rings, known as 'Fatkhah' and have engraved on them a crescent surrounded by stars. The middle ring in the sand to the left is possibly a Zar ring.

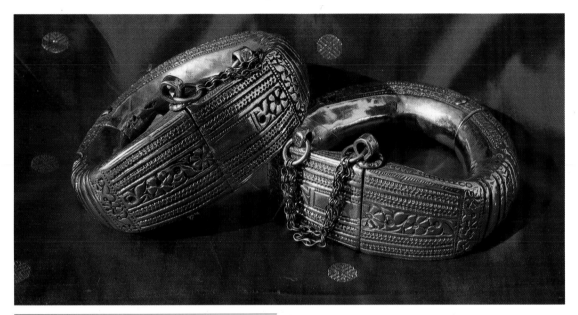

35. Silver anklets probably from Sur.

and boat building, both of which are still practised. A large proportion of a family's wealth was invested in a woman's jewellery and the Khanjar daggers worn by men. Silver rose-water sprinklers, the typical Omani shaped coffee pots, incense burners and trays which were used in formal entertaining and hospitality, were of value and often of great beauty.

Silver and gold has been worked for thousands of years. Babylonian and Sumerian tablets record that silver and copper was used for trading between Ur, in Mesopotamia (Iraq), and Magan which was almost certainly present-day Oman. The silver is thought to have been mined in the Isfahan region in Persia. However, for the past two hundred years silver for jewellery has been melted down from the Maria Theresa thaler or dollar. This coin, first minted in Austria in the eighteenth century, was immensely popular in the Arab world because of its silver content and particularly so in the Arabian peninsula. The British Raj in India minted it during the early twentieth century for export to the

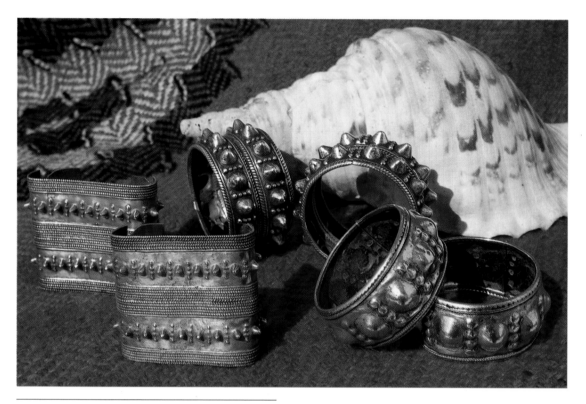

36. The D-shaped bracelets with sharp bosses possibly come from Ibra. Such bracelets with the rather ferocious spikes were worn all over the Arab-Islamic world, such as in Egypt, Nubia, the Yemen, India, Pakistan etc. In some countries the bosses were thought to represent breasts and were worn only by married women. In other countries warlike connotations were given to them . The other two pairs are now made in gold rather than silver.

peninsula. Besides their use when melted down for making jewellery, the coins were placed decoratively on necklaces and pendants.

Gold and silver, which represent the sun and the moon, have long been recognised not only as suitable materials for adornment but also as invest-

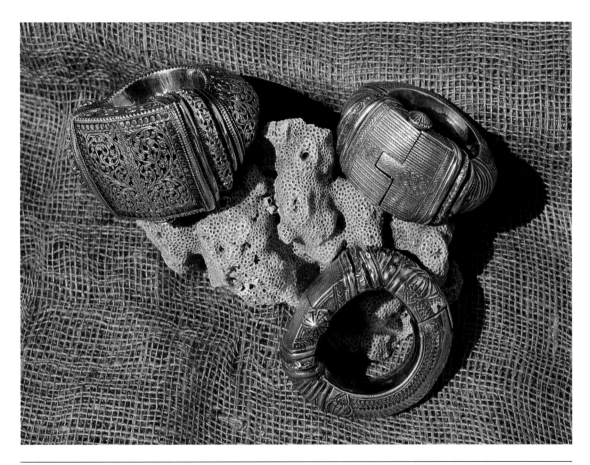

37. Silver anklets probably Nizwa and Ibri. These large anklets are worn at weddings and other celebrations. They are held together by a large silver pin. Possibly some of the designs originated in India (or vice versa) for there is an old trading link between the Gulf and Oman with India.

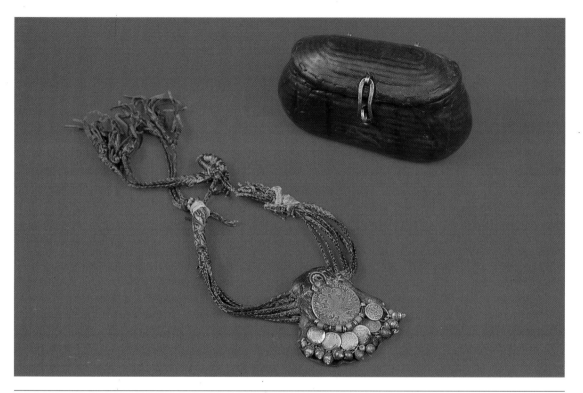

38. A plaited leather necklace with a Maria Theresa Dollar and a cosmetics container. Dhofar.

ments. Both possess amuletic properties for protection against misfortune and evil. Silver is believed to avert the evil eye. Still to be found are fox claws and teeth and old glass stoppers carefully set in silver and worn as pendants or attached to necklaces. More rarely found are what appears to be a group of small silver figures hanging from a silver chain. They are reputed to have been worn and maybe made by pregnant women to aid them in childbirth. There are small neat silver anklets with rounded finials, possibly representing snake heads, worn by small boys until they are about three years

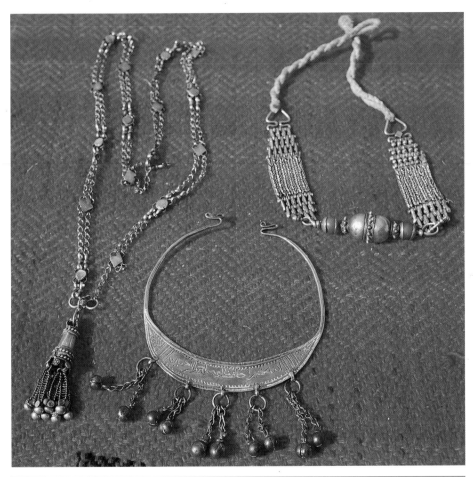

39. L to R " Sanqad" or "Manjad' from Dhofar that was worn over the shoulder like a bandolier. This style was worn by women not only in Jordan but during the Byzantine period as well. A neckpiece with a line engraved in Arabic from the Holy Qura'n " Allah alone who is the Best Protector and the Most Merciful of all". A necklace from Sur.

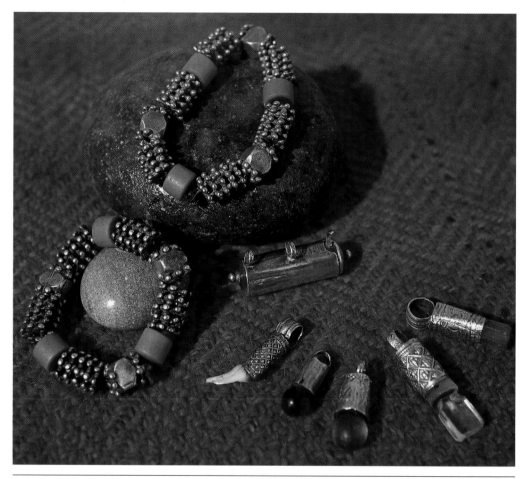

40. "Malnaut" bracelets from Dhofar of silver and red stone. Sometimes coral takes the place of stone or glass. The silver ('hirz') container near the stone is probably a boy's amulet known as "Ud Salib'. A piece of wood was inserted inside to protect the wearer from evil spirits. The claw and silver covered perfume bottle stoppers were amuletic and worn round the neck on a chain.

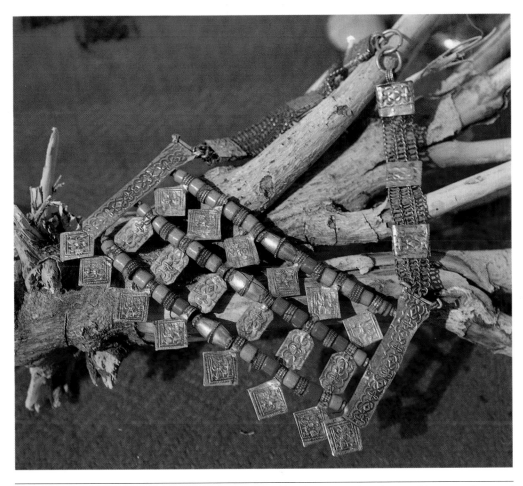

41. "Shebaq " This necklace was most likely made in Nizwa, although it seems to have been widely worn in Oman and the UAE. It is made of silver, the stamped plaques with gold overlay, and beads of both coral and red stones.

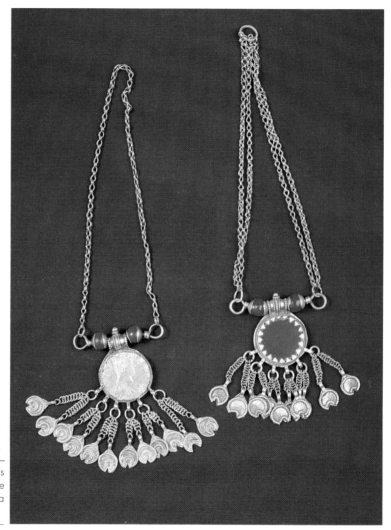

42. "Selma". A red bicycle reflector light is used in the example on the right . It is the red colour that is important, for red is a lucky colour and anyway looks nice.

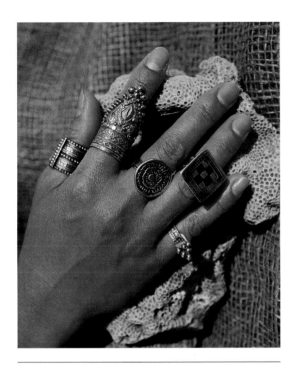

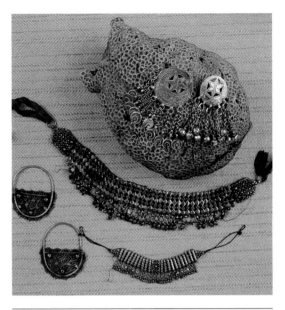

44. Two crescent and star brooches and two neckpieces and a pair of earrings.

43. The set of 10 rings once presented to brides, one for each finger starting with the thumb" Jabiyrah, Shawahid, Mahar, Kanabir and Khanafir The last 'Khanafir' was sometimes set with a stone.

old. Another amulet worn by boys was the 'Ud Salib', a silver case with a piece of wood inserted in it and suspended from a silver chain. One noticeable thing about Omani chains is the large variety of styles which are sometimes intricately worked. On turning over some of the large neck medallions, which are worn both in the Wahiba Sands and elsewhere in Oman, one is surprised to see a crudely etched stick figure which is reputed to be a djinn. Djinns are beings of fire, as opposed to humans who are formed from clay. Djinns can assume various shapes and have the capacity to bring harm to humans as well as help. In the case of the representation, if that is what is intended,

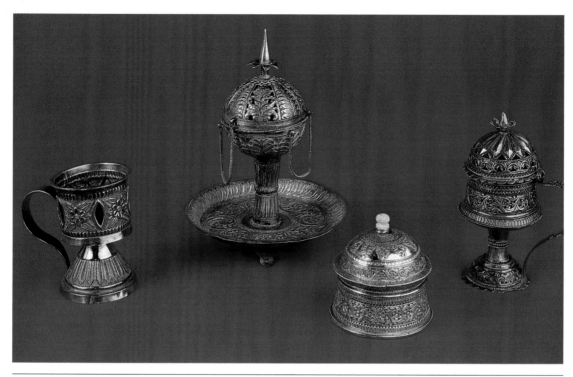

45. Silver Incense burners . The Dhofari women make brightly coloured clay incense burners. A small silver container perhaps for holding women's cosmetics.

the djinn has been "caught" on the back of the medallion to avert any misfortune. More often on a medallion there will be written the Fatiha, the opening verse from the Holy Qur'an or Ayat al-Kursi.

The Khanjar, or Omani dagger has a scabbard not only of great beauty but also distinguished by its near right angle turn at the pointed end. Although Nizwa is particularly famous for its specialist knife makers, the silver work on scabbards varied in style from town to town. In the past

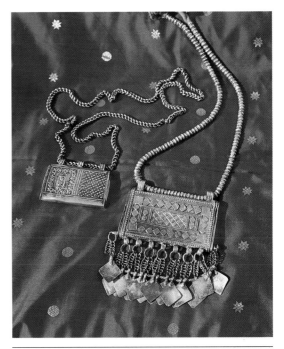

46. Two 'Hirz' to be worn round the neck and that were used to hold religious writings. The one on the right is probably from Nizwa and has gold leaf pressed over the decorations and one on the left might be from Ibri.

rhinoceros horn, with its virility and aphrodisiac aspects, was used for the hilt, but now bone, wood and latterly plastic are to be seen. Both hilt and scabbard are decorated in knitted, embossed and applied silver work. Khanjars are worn on belts that range from a mere webb or piece of rope to an intricately woven belt held by a fine engraved silver belt buckle. A superior dagger is considered

to have seven silver rings on its sheath, two which hold the belt and five through which silver thread is woven. However this is not a proven fact.

Until boys reached the age of puberty and entered man's estate, they wore belts with smaller embossed or engraved silver buckles. The silversmith

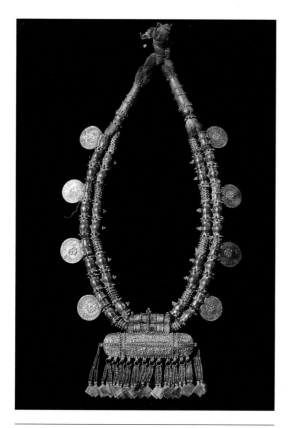

47. 'Hirz' Probably from Nizwa, also worn by the Bedu women of the Wahiba Sands as well as other tribes.

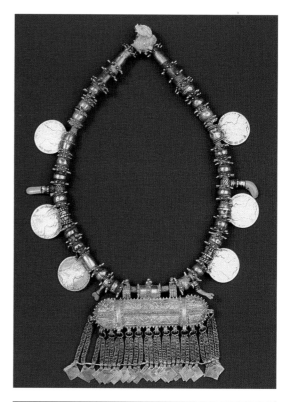

48. 'Hunkun ' or 'Hirz' These necklace of spectacular and original design are worn by women in the Wahiba Sands (see photos 9 and 24) . Such necklaces were made in Nizwa and possibly in other towns such as Al Hamra, or Sanaw which is the market town that caters to the Bedouin from the Sands.

prepared a mould for the buckles by pressing a finished one between two bits of cuttle-fish bone, or by engraving or incising a pattern into the bone.

The two halves were then tightly held together by clamps and molten silver poured inside through small hole. Sometimes at the back of a Khanjar

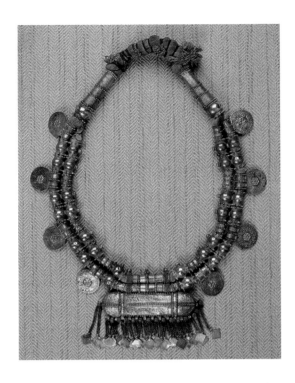

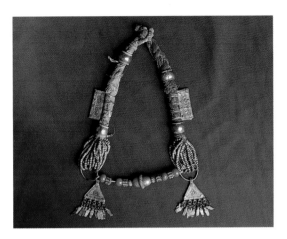

49, 'Hirz' Probably from Nizwa, also worn by the Bedu women of the Wahiba Sands as well as other tribes. (See photo No. 21)

there is a leather sheath for holding a workaday steel knife possibly with its hilt extravagantly decorated in silver. The dagger, originally defensive in purpose, has long been purely ornamental though still worn by many men, and in this modern era is part of the dress of a government official. Aside from their Khanjar and possibly a silver ring, little else is worn by men that can be thought of as jewellery. A man's ring will always be of silver because gold ornaments for men, including rings, are

unlawful according to a number of Hadith (sayings of the Prophet) though silver ones are permitted. A ring with a stone, often a red one of glass or carnelian called Fatkhah and incised with a crescent moon and star is most commonly seen. The Prophet Muhammad was thought to have worn a similar ring inset with a carnelian. Such rings have also been used as a proof of identity and given as a pledge. One ring somewhat different to the rest that is occasionally worn by both men and women was the Zar ring. These round, dome-shaped, slightly cage-like rings of filigree were worn by either sex at a special ceremony undertaken to rid a person or a property of a spirit called Zar. Such an

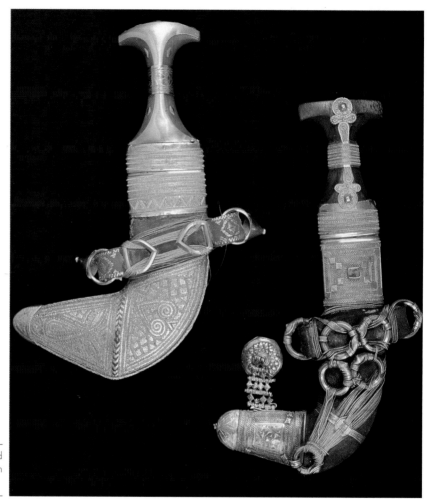

50. 'Khanjar' - The right hand one might have been made in Ibri.

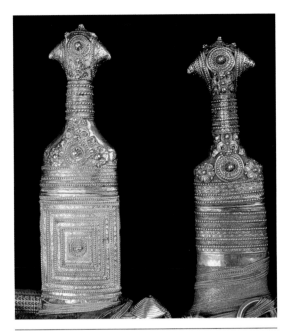

51. The tops of two 'Saidi' daggers. The tale is that the Persian wife of Sayyid Said bin Sultan became bored with the style of the dagger and designed a new one.

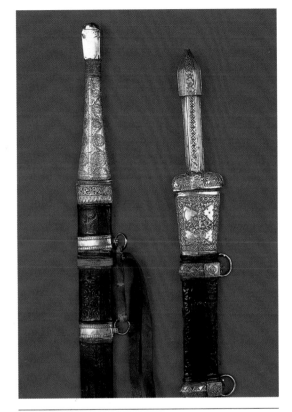

52. Details of Omani Kattara.

occasion has been accurately recorded by the explorer and traveller Wilfred Thesiger in his book Arabian Sands.

The other group of rings are those worn on each finger of both hands which are reported to be given to women as part of their bride wealth. The rings probably change names in different regions. Starting from the thumb a broad silver ring, some-

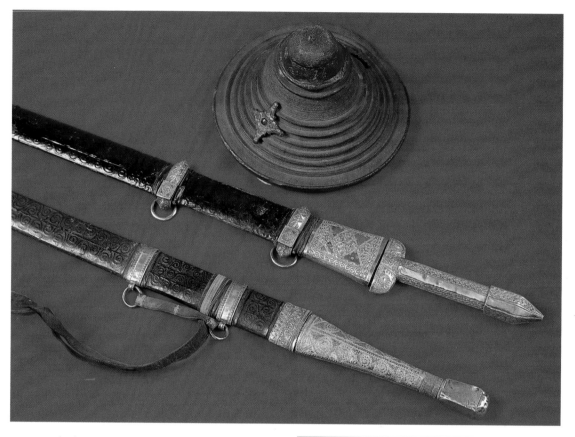

times with the top pattern decorated with a little thin gold ring, sometimes with the top pattern decorated with a little thin gold sheet, is called, Jabiyrah. The pointed ring worn on the forefinger is Shawahid or possibly more commonly known as Shahadeh. This is the finger the Muslim points

53. Omani Kattara and small shield made from hide, probably originally imported from Zanzibar.

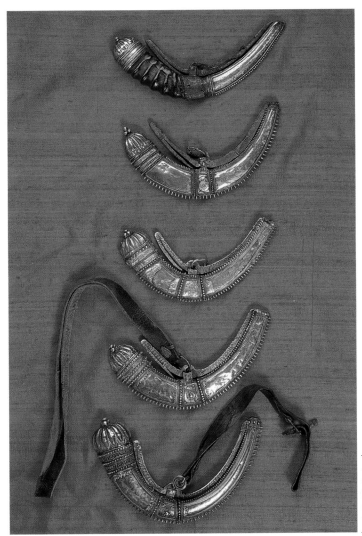

54. 'Talahiq ' or gunpowder horn . The top of each can be removed to insert the powder, the lever releases it at the end . The top 'Talahiq ' is made from goat horn encased with silver at the top and the bottom.

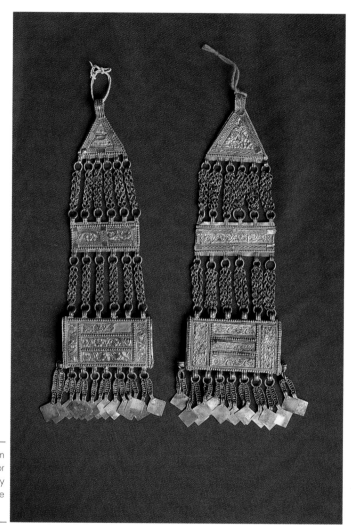

55. A pair of silver ear pieces that would be worn on either side of the head attached to the headdress or a silver chain across the top of the head. Probably made in Nizwa and with gold leaf pressed into the decoration.

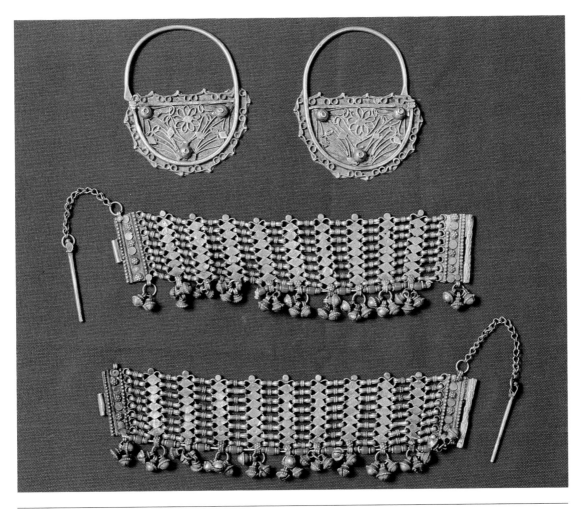

56. A pair of earrings and anklets from Muscat; Princess Salme appears to be wearing similar ones in the photograph . (No 32).

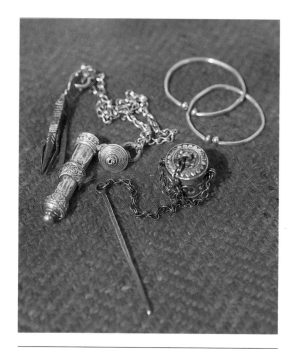

57. A man's tweezer and pick set, a woman's kohl pot with the silver stick for outlining her eyes, and silver anklets worn by small boys.

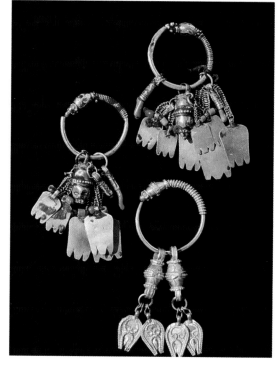

58. Earrings with beads and small branches of coral . They seem to have been worn in clusters attached to a headdress.

heavenward to indicate the oneness of God when he or she makes the Muslim declaration of faith, La ilaha illa Allah, Muhammad Rasool Allah (There is no God but God and Muhammad is the Messenger of God). The rings on the next three fingers are respectively Abu Fass, or Mahar, Abu Satma or Kanabir and Faiz or Khanafir. More research needs to be carried out on when these rings were given and their names in different places. They used to be found in great quantity in

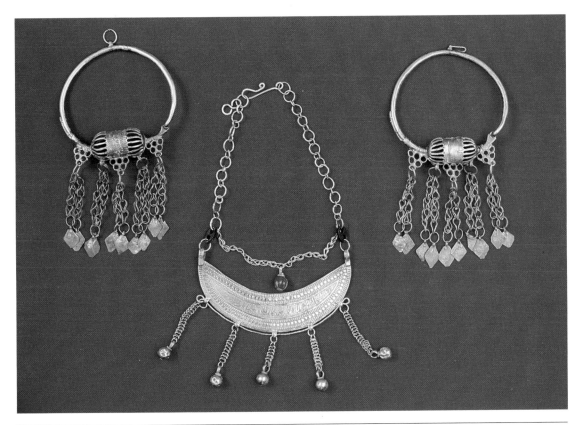

59. A pair of earrings and in the centre a neckpiece possibly worn by a young woman. The writing engraved on it reads" Allah alone who is the Best Protector and the Most Merciful of all. '

baskets, which implies that they were in demand, for sale in places like Nizwa, Muscat and Mutrah, but they seem to have been bought up and taken away by tourists and now are no longer so easy to obtain or of such good quality.

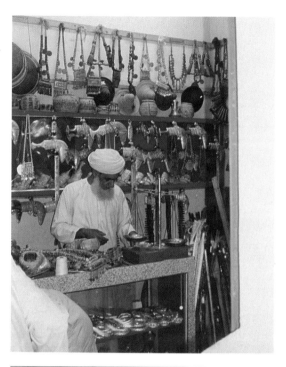

60. A window in a modern house in Tewi.

61. Ahmad bin Said al Suleimani in his jewellery shop in the new Nizwa suq.

▶

62. 'Batula' The stiff face masks worn by many women are thought to have entered Oman about 200 years ago from Gujarat in India, via Baluchistan and Persia. The 'fashion' spread amongst certain tribes and townswomen in Oman . The 'Batula ' could be seen in parts of Saudi Arabia and reached the UAE, Bahrain, Qatar and the Island of Failaka in Kuwait. Mainland Kuwaitis never seem to have worn the 'Batula'. The 'Batula' was made of black indigo dyed material which when rubbed with a flat stone becomes iridescent. In other places, as in these examples it was heavily embroidered and in the south of Iran it was a deep red colour. Each woman made her own mask to the style of her tribe but to suit her features. The women of Lingha and Bandar Abbas in Iran were well known for making the ' Batula '.

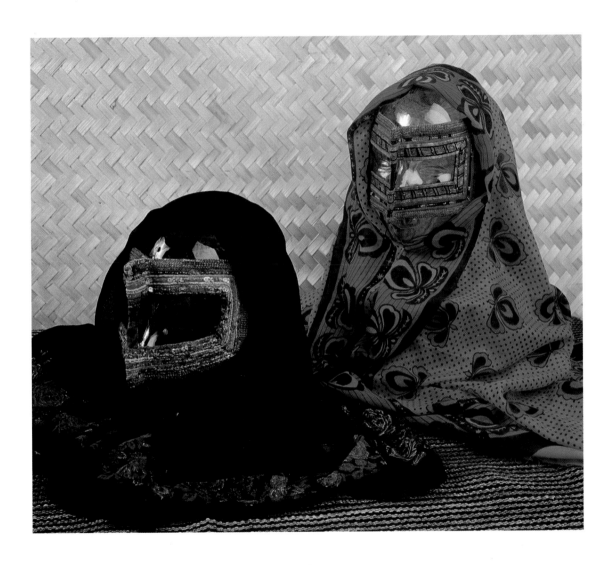

63. A tree buffeted by the prevailing wind along the route to Tewi and Sur.

64. Spinning silk thread in Sur.

The only other item apart from silver powder horns which hung from a man's belt are tweezer and pick sets that fit into silver cartridge-shaped cases. They too sometimes have a small amount of gold sheet pressed onto the decoration. Gold sheet decoration appears on quite a lot of Nizwa work on Hirz, or amulet cases, as well as rings and Khanjar. Men and women use the silver tweezers and pick sets, especially in the interior where there are scrub and thorn bushes and people wear sandals. Sometimes included and fixed into a man's headdress are kohl cases filled with black antimony and a stick for outlining the eyes. Kohl was made by mixing wood ash, or powdered antimony, a little ghee and rose-water and was considered not only to enhance the appearance, but also to deflect the glare of the sun and so improve the sight. Men's applicators hung from the silver cartridge-shaped cases, women's from small silver pots. There are neat little silver spikes on a small chain that are used by women for making the hand embroidered men's caps.

Men's head wear is varied with bright cashmere turbans or white head cloths worn in the interior and crotcheted or embroidered caps (Khumar) along the coasts. The last are now quite popular in the towns of the interior. These days many embroi-

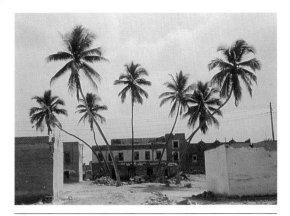

65. Coconut trees in Salalah .

66. This beautiful piece of jewellery must also have been worn as a headdress with the four triangular drops on either side of the head over the headwraps.

dered head caps are made in shops by machine embroidery with floral decorations that appear very Indian in conception. However, women can still be seen working in the cool of an evening, perhaps on the beach if they belong to a fishing village, on caps for their menfolk as well as for sale in the market. First the pattern is pierced out with a bodkin and then worked in tiny buttonhole stitches (najum or stars) usually in geometric patterns. There is an attractive grape and vine motif which covers the entire cap in tasteful beiges and browns. The machine embroidered caps tend to be more vibrant in colour but just as tasteful. The dress of both men and particularly the women are probably amongst the most sparkling and colourful in the Arab world, perhaps owing something to India and

Africa. For a thousand years Oman had an empire that stretched to both places and Omanis traded and voyaged leaving their mark everywhere they went. Zanzibari jewellery was almost indistinguishable from that found in Oman and no doubt many silversmiths must have gone with their families to

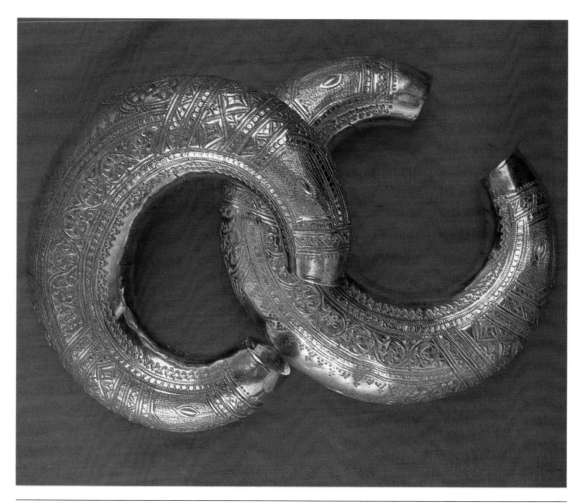

67. Heavy silver anklets with either end shaped as a snake's head . The origin of these was probably to ward off evil or the evil eye.

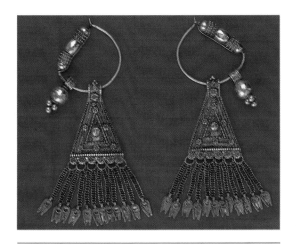

68. A pair of ear pendants that were possibly used in the Dhofar region.

69. Bracelets perhaps made in Nizwa . Princess Salme (No. 32) appears to be wearing a similar type although hers were probably made in gold.

East Africa and remained there. Baluchistan was a part of the empire and Khojas from Hyderabad in Sind also settled in Mutrah a number of generations ago. They too have left their artistic mark behind in various motifs and patterns.

A particular style of Khanjar that can still be found is ornate, heavily decorated, with its hilt of vaguely cruciform shape. The usual dagger has a flat T-shaped top. Tradition maintains that the "new" style belongs to the Saidi or Royal Family of Oman. The story goes that the Persian wife of Sayyid Said bin Sultan (ruled 1804 1856) grew bored with the curved top of the "normal" one and redesigned it for posterity.

Most of a woman's jewellery is first presented to her upon marriage and this is true throughout the Arab/Islamic world. Besides various neck pieces, anklets, bracelets and possibly a nose or toe rings, all if possible would be part of the dowry. Strictly speaking in Islamic law what has been given to her as her bridal wealth is supposed to be hers alone. In practice in many places it became part of the family wealth in the days before there were banks. Traditionally in Oman a bride was found through the recommendation of friends.

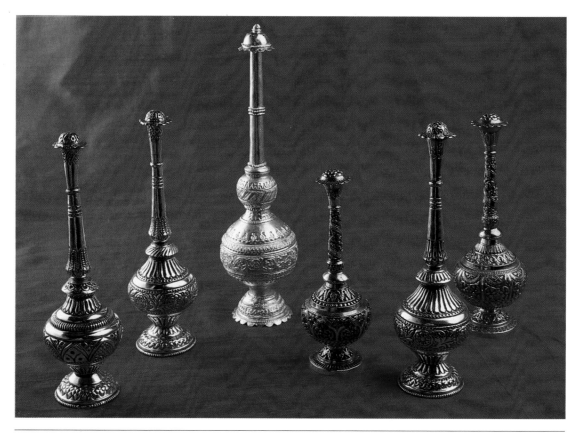

70. A collection of Rose water sprinklers, some stamped 'Made in Oman' and one with 'Nizwa ' engraved on the bottom.

The prospective groom's father accompanied by a close friend would visit the girl's father. He then considers the matter asking into account his daughter's views, as well as if necessary, making enquiries about the young man's suitability. If the marriage was agreed upon and when the dowry has been set, about one week before it is presented to the bride the villagers will be told what is going to happen so

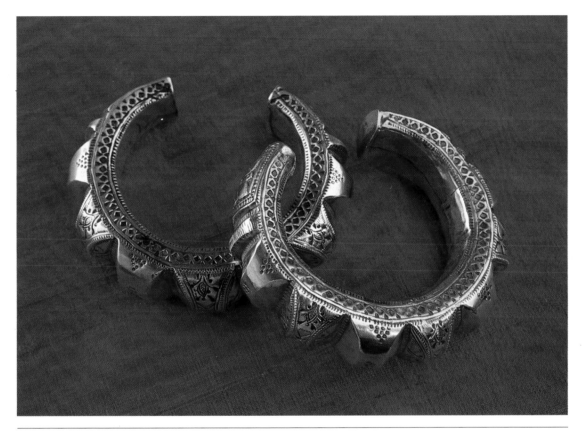

71. A pair of bracelets made in Nizwa.

giving them time to prepare for the ceremony. On the due date the ladies would put trays containing the wedding gifts, covered with green cloths and scattered with sweet basil and roses, on their heads to walk to the bride's house. She would be waiting for them expectantly and remove the cloths from

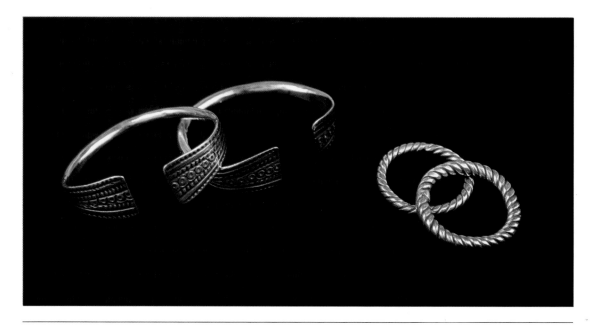

72. A child's silver bracelets and two toe rings from Dhofar.

the trays to reveal to everyone the gifts she has received from the groom. These gifts would be items of jewellery, clothing and material, money and perfume as well as linen for their future home.

Approximately a week before the wedding day the bride is dressed entirely in green (the colour of fertility) and places a green veil over her head. While she is sitting at home with her relatives the man goes to the mosque with his friends and relatives. The religious sheikh arrives at the bride's house to greet the bride, who is sitting on a prayer mat, to ask her three times if she agrees to the marriage. She must give her consent each of the times she is asked. If she has agreed the sheikh returns to the mosque where the groom is waiting. He is given advice on how to take care of his future wife, and after the marriage contract was signed and sealed

73. Wadi Bani Khalid

then verses from the Qur'an are recited and rosewater sprinkled around. The groom then goes to the house of the bride, where he is admitted, puts his hand on her head and recites the first sura (chapter) from the Qur'an and leaves to return to his family.

Two important Henna ceremonies take place, the first a quiet affair only for the relatives of the bride. (Henna is the plant lawsonia inermis which when powdered and mixed with water dyes a deep red colour.) The next Henna night takes place when both families gather to paint henna in attractive and originally amuletic patterns on her hands and

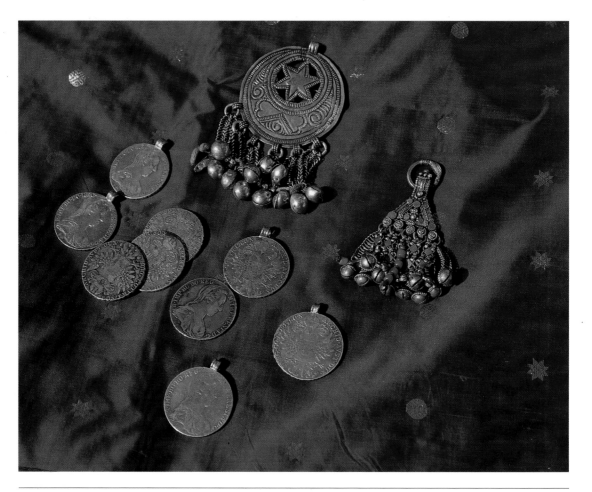

74. A star and crescent brooch and a 'sils' or scarf weight and Maria Theresa dollars. The latter were used until the 1950s in Oman. They were of high quality silver content and often melted down for the making of silver jewellery.

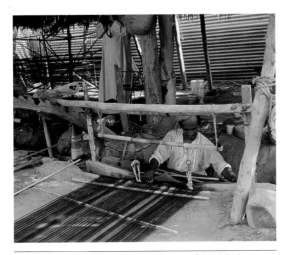

75. Zael bin Khalid bin Selim Daoudi, one of the skilled weavers of Sur still producing fine shawls, scarves and lengths of material.

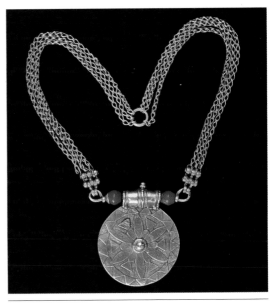

76. 'Kokh' This gold leaf decorated pendant has a little anthromophoric stick figure engraved on the back.

feet. The bride sits on the big bed which has been decorated with mirrors, her new jewellery displayed on the curtains and with only her feet showing adorned with large silver anklets. The henna arrives on a tray covered in green cloths and an expert woman artist applies it with a stick in intricate patterns. As henna has to stay on for some time to get a long lasting deep colour, there is time for the groom to arrive with his male friends and relatives. They march into the room in procession, each person throwing some paper money over the bride's feet and then leaving. On the fourth and last night the bride once again wears a green dress

and a green veil. All the relatives and friends will be present, the bride will put on her new jewellery, rings, necklaces, bracelets and anklets, and there will be singing and dancing until about ten in the evening. The relatives of the groom arrive at the bride's house to ask for her and have to spend a period persuading her family to allow her to leave. Finally the bride is taken by them to the bridegroom who is waiting for her in his house. As the couple meet at the entrance the bridegroom puts

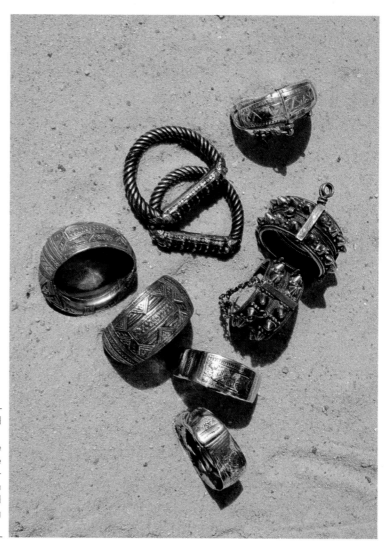

77. Bracelets from Dhofar, Nizwa, Ibri and Sur. The ones with gold leaf to the front of the picture were probably made in Ibri, the 'D'shaped bracelets('mhadabit') are Dhofari. The 'mhadabit' are somewhat reminiscent of a style in Indonesia. They have a bell type decoration at the top and are held in the hands and shaken while performing dances.

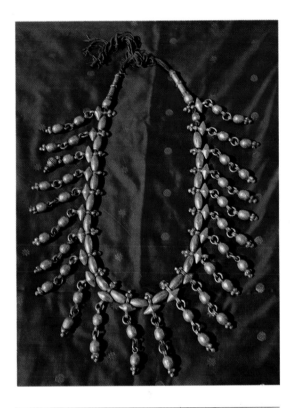

78. A fine silver necklace - an example is being worn by the Bedu lady in the photograph of the woman from the Wahiba Sands (No. 9) .

home to visit her family and friends, while the groom holds a big celebration for his relations and friends.

These days, depending on the wealth of a family, the bride will receive gifts of jewellery which certainly in the towns will now tend to be made of gold rather than silver. Some of the styles will repeat the old ones, other pieces will be more Indian in concept or perhaps European. The author has been to a wedding where the bride was wearing a pair of big heavy anklets of gold rather than silver. She had her hands and feet delicately hennaed in intricate and floral type patterns and she sat dressed and veiled in green inside a brocade decorated hut on a dais, which represented the big bed of the past. As it was an important affair this official Henna night took place in a large public hall that was hired for such occasions. Her jewellery was displayed on the brocade and at least five hundred women, friends, relatives and acquaintances crowded the hall. Professional women drummers and singers entertained with their wedding songs. One was famous and able to sing songs from all over the Gulf. Young girls got up and danced for the pleasure of the bride and the visitors. Their dances ranged from the traditional small foot movements and tossing of loosened, luxurious locks of hair, to the Egyptian or Lebanese versions of a belly dance. The last were

his big toe over the bride's big toe and an egg is broken over them. This is washed away with rosewater and the bride is received into her new home. After about a week the new bride returns to her old

sometimes mixed with elements of movement that looked suspiciously modern pop.

Halfway through the function the doors suddenly crashed open and the groom appeared with all his male relatives and friends behind him. A brief silence fell on the gathering, then the good looking, self-possessed young man began his slow walk up the hall towards the bride to the accompaniment of loud ululations from all the women. This quite awe-inspiring sound from five hundred women raised the hair on the back of the neck. It was clear, that except for the groom, most of the men were quite overcome and absolutely petrified! They tossed their notes before the bride's feet and almost fell over their own in their hurry to get away from the women and out of the hall. Thereafter the dancing resumed, food and soft drinks were provided and everyone dressed in their best chatted and enjoyed themselves. The last part of the wedding ceremonies took place the next day when the bride, this time in a white wedding dress, sat on a dais where her groom joined her and they were seen together as a couple. Afterwards she would go to his house and the marriage would begin.

Last, but by no means least and somewhat different in conception to the silver jewellery of the ordinary person, is a splendid gold necklace that originated in Zanzibar which was an Omani possession until 1964. Until the Tareq Rajab Museum acquired this large and important Islamic medallion necklace with Quranic inscriptions, it belonged to a family who maintained it had been presented to their ancestor by Sultan Said Bargash, Sultan of Zanzibar (ruled 1870-1888) for services rendered to the Sultanate. It was his father Sultan Said bin Sultan of Oman and Zanzibar whose Persian wife is supposed to have redesigned the Khanjar mentioned earlier in this article. From a description she sounded a woman of some character and vigour. Arriving in Zanzibar from the court in Qajar Persia, she shocked many people by riding astride horses, going hunting and refusing to wear any kind of a veil. Eventually, because there were no children from the marriage, she was divorced and returned to Persia, with one feels some relief. The Sultan's sister, Princess Salme, who wrote about her father and her life in Zanzibar, is pictured wearing a necklace that is very similar to the museum's one.

Sultan Said Bargash was desirous of making a State Visit to England to meet Queen Victoria and it was through the good offices of the family's ancestor

▶

79. The plaited leather head piece with coin-shaped silver roundels made by the women of the Wahiba Sands. Each cap is individually made for and by that person alone. The leather mouth and nose veil came with the cap.

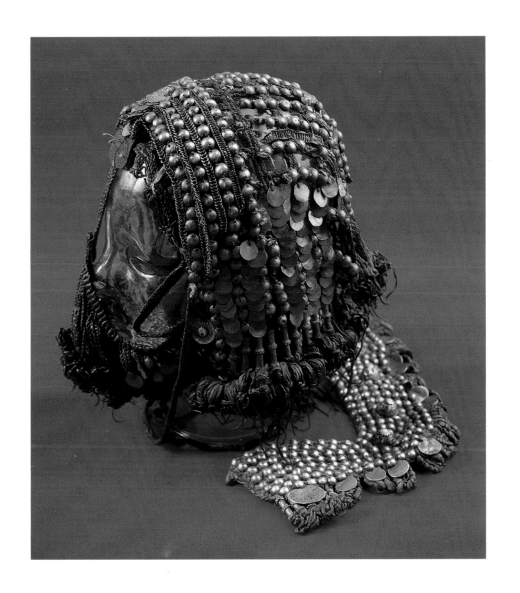

that the visit was arranged and was a successful one. On June 21st, 1875, he arrived in London at about 9:30 in the morning with the entourage and the following was recorded in "The Times" newspaper:

"His Highness was then led from the steamer by Mr. Bourke, and followed by his suite, ascended the steps. The band played 'God save the Queen', and the crowd cheered slightly. The Sultan, who, with his followers, is a strict Mohammedan, wore a turban, a waist-sash, a long flowing robe of silk beautifully embroidered, the jamvie or dagger, and the scimitar. "

The article continues that the party entered their carriages and at a slow rate went in procession up by Pall Mall, St. James's and Piccadilly to the Alexandra Hotel, at Hyde Park Corner, where the Sultan had chosen to reside during his visit. During his stay the Sultan met Queen Victoria and visited Birmingham, Liverpool and Manchester before embarking for a short visit to France on his way back to Zanzibar. At the conclusion of this successful visit the ancestor of the family was, no doubt, amongst other things, presented with the gold necklace.

The necklace worn by Princess Salme in the photograph (No.32) which is dated Hamburg 1868. According to some historians it is the one given to the ancestor of the family that arranged the Sultan's visit to Britain in 1875 and is now in the Tareq Rajab Museum. Due to various problems Salme had left Zanzibar in 1866 and was living in Germany when her brother visited Britain in 1875. It is possible that the necklace had got back into the Zanzibar Treasury stores some years after the photograph was taken and was then presented for services to the state. Such items were kept and carefully recorded before being given as gifts to both family and important visitors.

Princess Salme in her book (*"An Arabian Princess Between Two Worlds"* / E J Brill / Leiden / 1993) describes how her father the Sultan organized his Treasury which contained everything needed for the presentation of clothing, jewellery etc; to family, visitors and important guests. She comments too how every woman had to have her jewellery, to such an extent that even "beggar-women may be seen plying their trade decked out in them." She mentions that her father, the Sultan who liked the greatest simplicity for himself did not permit even the youngest child to appear before him unless fully dressed. She goes on to say that "We little girls wore our hair just in thin plaits (often as many as twenty); on both sides the ends were tied obliquely, and from the centre a heavy gold ornarment, often set with precious stones, suspended on the back." This sounds much like the hair ornament (top No. 28) of silver worn by young girls in the same manner in Bahla and Jabrin. She describes

this ornament as usually in the form of a full moon with a star inside.

Most of the Arab/Islamic world has appreciated and taken pleasure in jewellery for its beauty, its amuletic and status functions, as well as a source of finance in difficult times. Nowhere has this been more true than in the Arabian peninsula and especially in the Sultanate of Oman which had silver and goldsmiths of such distinction.

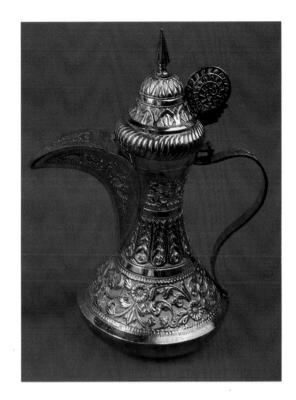